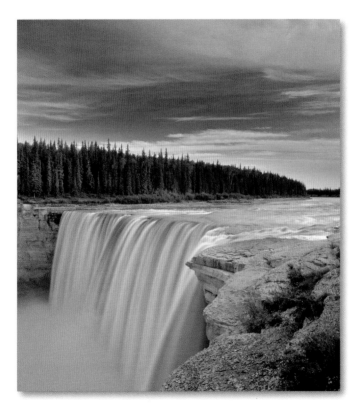

The Little Gift Book *of*
CANADA

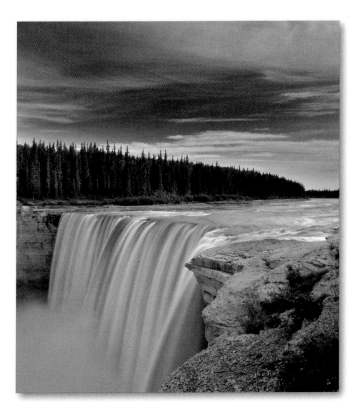

whitecap

© Copyright 2008 Whitecap Books

All rights reserved. No part of this publication may be reproduced, stored in a retrieval system, or transmitted in any form or by any means, electronic, mechanical, photocopying, recording or otherwise, without the prior written permission of the publisher.

The information in this book is true and complete to the best of our knowledge. All recommendations are made without guarantee on the part of the author or Whitecap Books. The author and publisher disclaim any liability in connection with the use of this information.

For additional information, please contact Whitecap Books, 351 Lynn Avenue, North Vancouver, BC V7J 2C4. Visit our website at www.whitecap.ca.

Written by Claire Leila Philipson
Photo selection and design by Claire Leila Philipson
Edited by Grace Yaginuma
Proofread by Joanna Karaplis
Front cover photograph by Darwin Wiggett

Printed and bound in Hong Kong

Library and Archives Canada Cataloguing in Publication

Philipson, Claire Leila, 1980-
 The little gift book of Canada / Claire Leila Philipson.

ISBN 1-55285-944-4
ISBN 978-1-55285-944-5

 1. Canada--Pictorial works. I. Title.

FC76.P49 2008 971.07'30222 C2008-903420-1

The publisher acknowledges the financial support of the Government of Canada through the Book Publishing Industry Development Program (BPIDP) for our publishing activities and the province of British Columbia through the Book Publishing Tax Credit.

Stretching from the shores of the Pacific Ocean to the Atlantic Ocean and from the Arctic Ocean in the north to the American border in the south, Canada is a massive territory that supports incredibly diverse landscapes and cultures. From immense mountain ranges and vast expanses of wilderness to picturesque towns and cosmopolitan cities, Canada's many varied regions do share some commonalities—natural beauty and a history steeped in adventure.

This rugged land has been home to First Nations and Inuit people for thousands of years. Some 12,000 years ago, at the end of the last ice age, Canada's first residents are believed to have crossed the Bering land bridge to come to North America from Asia.

This ancient sense of adventure has been mirrored by a host of European explorers who visited this land to discover a new world, map it, and establish colonies in the names of their homelands. A group of Vikings led by Leif Eriksson in the first millennium established a short-lived settlement in what is now Newfoundland and Labrador. Hundreds of years later Italian explorer Giovanni (John) Cabot rediscovered Atlantic Canada and claimed it for England.

The European presence in Canada grew in the 16th century. Notably, Jacques Cartier arrived from France and explored the St. Lawrence River and Martin Frobisher arrived in Northern Canada looking for both gold and a passage to Asia. In the years that followed, a host of other explorers ventured onto Canadian soil. Samuel de Champlain established a trading post in Quebec. Henry Hudson discovered Hudson Bay while he was looking for the Northwest Passage. Simon Fraser explored the Fraser River and David Thompson navigated the Columbia River.

These bold journeys have all played their part in shaping the borders of contemporary Canada. From the first human footsteps on this landscape to the formation of the territory of Nunavut in 1999, Canada's history tells a tale of adventure and change.

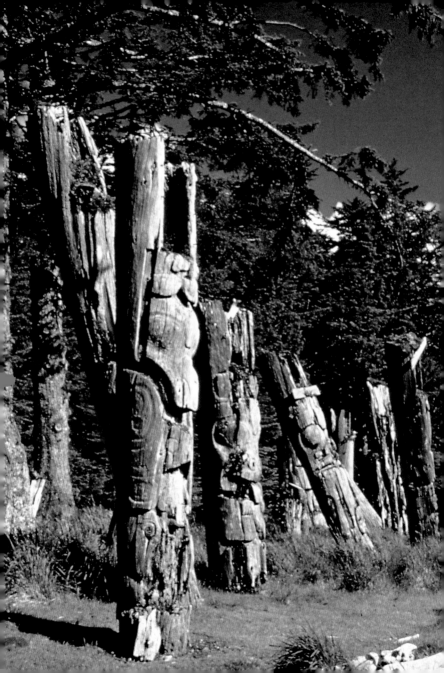

Ninstints | BRITISH COLUMBIA

These weathered mortuary totem poles indicate the site of *Ninstints*, a once-thriving Haida village in British Columbia's Queen Charlotte Islands. An outbreak of smallpox in the late 19th century annihilated the majority of Ninstints's Kunghit Haida population, and these poles and the ruins of a few houses are all that remain.

> *It is wonderful to feel the grandness of Canada in the raw, not because she is Canada but because she's something sublime that you were born into, some great rugged power that you are a part of.*
> —EMILY CARR, ARTIST & WRITER

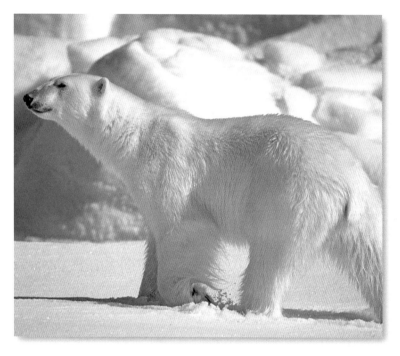

Polar Bear | NUNAVUT

The Canadian Arctic is home to almost half the world's polar bear population. These massive mammals are the world's largest predators living on land—males can weigh up to 600 kilograms (1,300 pounds).

Writing-on-Stone Provincial Park | ALBERTA

Hoodoos jutting out of the landscape at Writing-on-Stone Provincial Park create an otherworldly landscape. The hoodoo's hard capstone protects its soft rock spire, which is created by thousands of years of wind and water erosion. When the capstone falls off, the rock towers disintegrate.

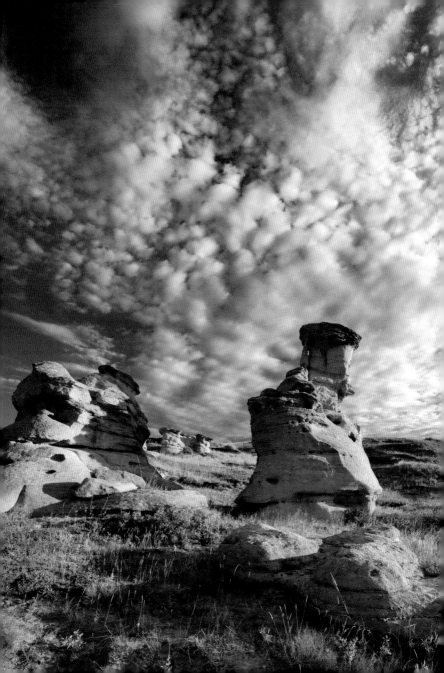

Hudson Bay | MANITOBA

First Nations people, primarily Cree and Sioux, made up the population of what is now Manitoba until the arrival of Europeans through Hudson Bay in the 17th century. Locked in ice for the better part of the year, Hudson Bay is an important habitat for polar bears—they use the massive icebergs as platforms from which to hunt seals.

HENRY HUDSON

Henry Hudson was a prolific English navigator and explorer. On his fourth major exploration, he sailed here to Hudson Bay. Although conditions were horrible, Hudson refused to turn his ship, the *Discovery,* around and head back to England. His crew mutinied, putting Hudson, his son, and a few loyal crew members in a small boat and setting them adrift. The *Discovery* returned to England, but Hudson and his companions were never seen again.

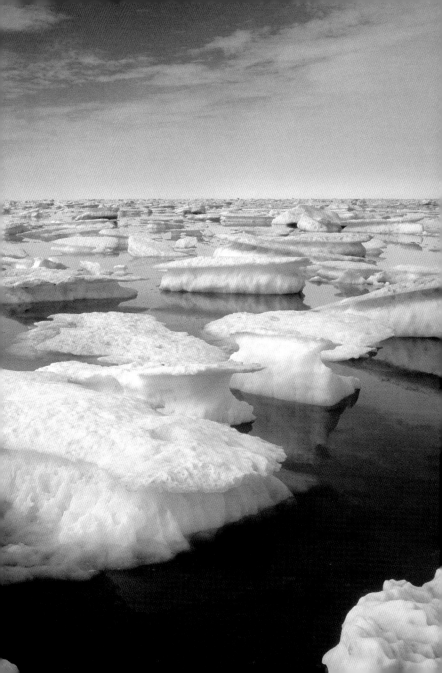

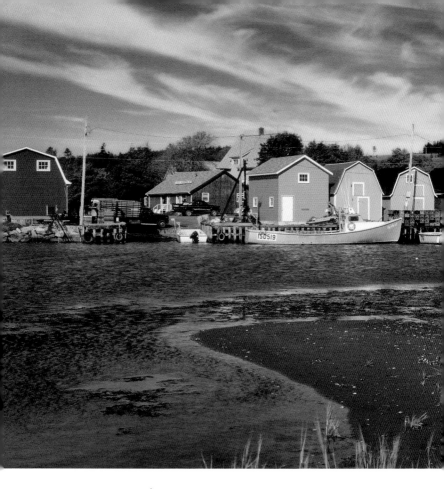

French River | PRINCE EDWARD ISLAND

Prince Edward Island's Mi'kmaq name is *Abegweit*, which means "land cradled on the waves." Bound by the Northumberland Strait and the Gulf of St. Lawrence, this island is Canada's smallest province. It is estimated that people of the Mi'kmaq nation have inhabited this area for ten thousand years.

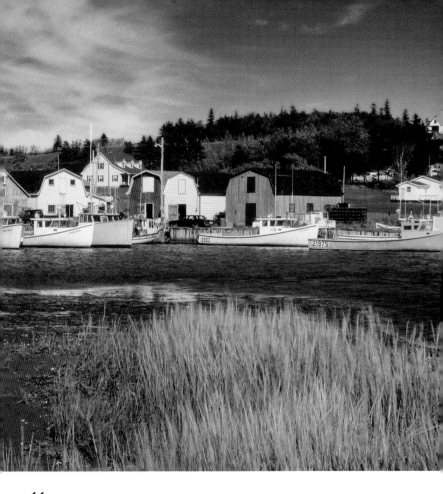

" *You never know what peace is until you walk on the shores or in the fields or along the winding red roads of Prince Edward Island in a summer twilight when the dew is falling and the old stars are peeping out and the sea keeps its mighty tryst with the little land it loves.* "

—LUCY MAUD MONTGOMERY, POET & WRITER

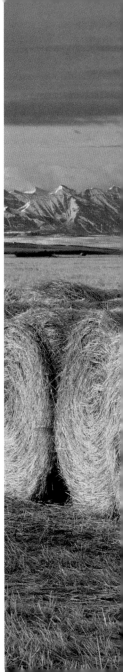

Canadian Rockies | ALBERTA

The Canadian Rockies offer some of Alberta's most iconic views, but the magnificent mountain ranges make up less than ten percent of the province. The rest of Alberta is comprised of urban landscapes, boreal forest, foothills, the Canadian Shield, and grasslands. The grasslands are where Alberta's crops are grown. Alberta is Canada's second-largest agricultural producer—almost half of the barley, 30 percent of the canola and wheat, and almost a quarter of the honey produced in Canada come from this province.

" *I like the endless riding over the endless prairie, the winds sweeping the grass, the great silent sunshine, the vast skies, and the splendid line of the Rockies, guarding the west.* "

—AGNES HIGGINSON SKRINE, POET & WRITER

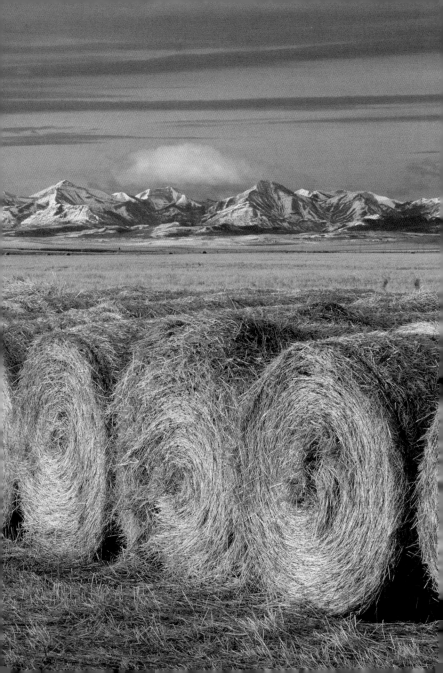

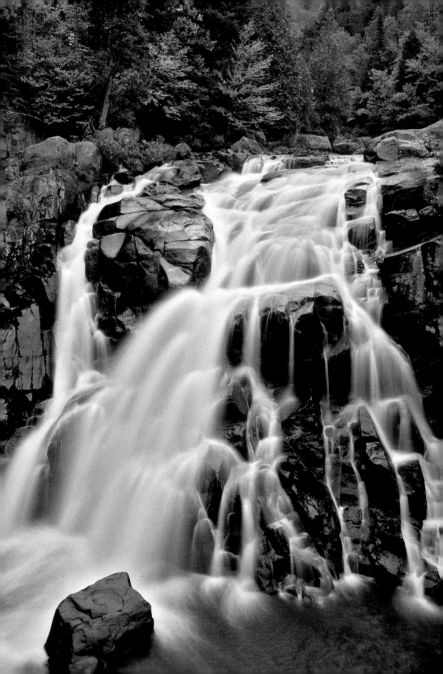

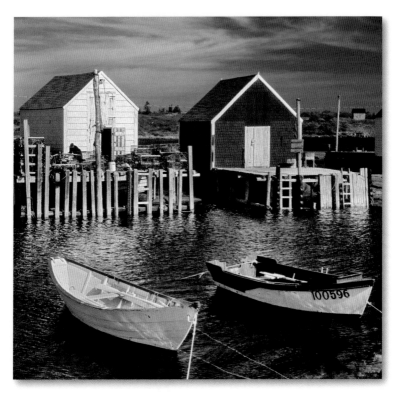

Blue Rocks Harbour | NOVA SCOTIA

A small fishing village on the shores of Lunenburg Bay, Blue Rocks is a reminder of Nova Scotia's maritime past. Fishing was one of the primary industries here for hundreds of years until over-fishing began to take a toll on the fish stocks.

Mont-Tremblant National Park | QUEBEC

This powerful 15-metre-high (50 feet) waterfall in Mont-Tremblant National Park is called the *Chute du Diable* ("devil's waterfall").

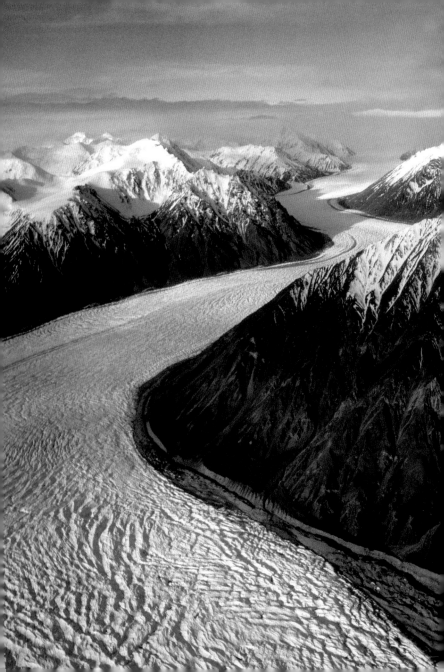

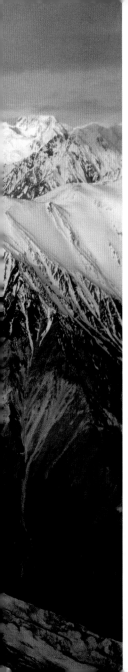

Kluane National Park | YUKON

Stretching over 21,000 square kilometres (8,100 square miles), Kluane National Park and Reserve is home to Canada's highest peak—Mount Logan. The park is comprised of the world's largest non-polar icefields.

" *This is the law of the Yukon, that only the Strong shall thrive; That surely the Weak shall perish, and only the Fit survive.* "

—ROBERT SERVICE, POET & WRITER

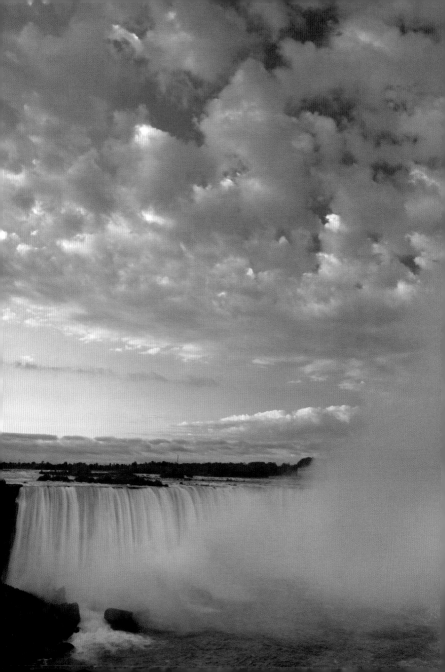

Niagara Falls | ONTARIO

Almost all the water from the Niagara River flows over Horseshoe Falls, the Canadian portion of Niagara Falls. An estimated 2,270,000 litres (600,000 gallons) of water cascade over the edge every second.

" *Whether we live together in confidence and cohesion; with more faith and pride in ourselves and less self-doubt and hesitation; strong in the conviction that the destiny of Canada is to unite, not divide; sharing in cooperation, not in separation or in conflict; respecting our past and welcoming our future.* "

—LESTER B. PEARSON, FORMER
PRIME MINISTER OF CANADA

Peggy's Point Lighthouse | NOVA SCOTIA

One of Canada's most iconic structures, Peggy's Point Lighthouse—
often referred to as Peggy's *Cove* Lighthouse—sits at the entrance
to St. Margaret's Bay. Many different legends offer explanations

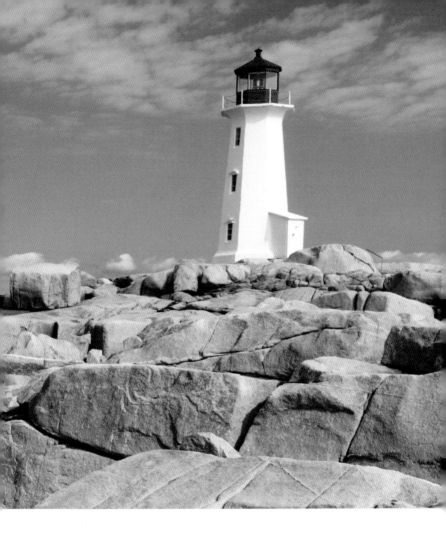

of the origins of the lighthouse's name, including one story that
tells of a woman named Margaret who was rescued by the people of
Peggy's Cove after a shipwreck here in the 19th century.

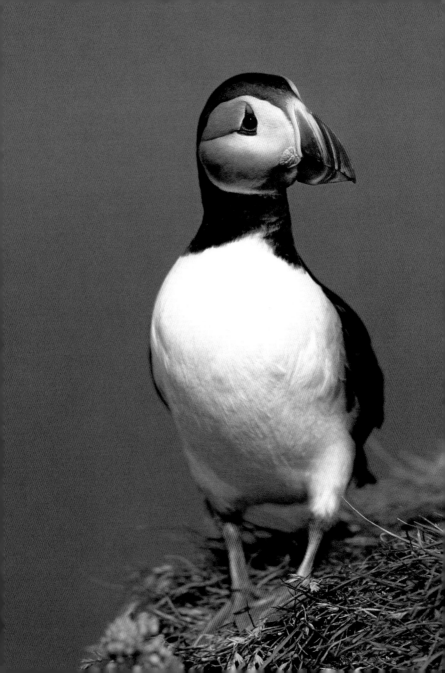

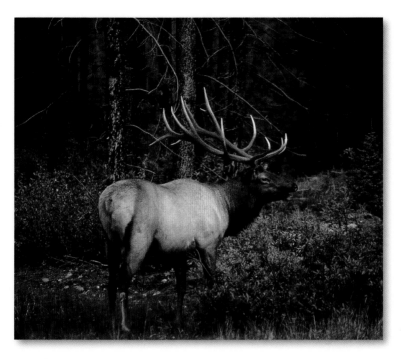

Elk | ALBERTA

The Canadian Rockies are host to a large elk population. These large mammals—they can weigh up to just over half a tonne—are also known as *wapiti*. Although predators like bears and wolves prey upon elk, they are one of the most common animals in the Rockies.

Atlantic Puffin | NEWFOUNDLAND & LABRADOR

Over half of Canada's Atlantic puffin population lives in Newfoundland & Labrador. Baccalieu Island, the province's largest seabird colony, hosts North America's second-largest Atlantic puffin community. The puffin is Newfoundland & Labrador's provincial bird.

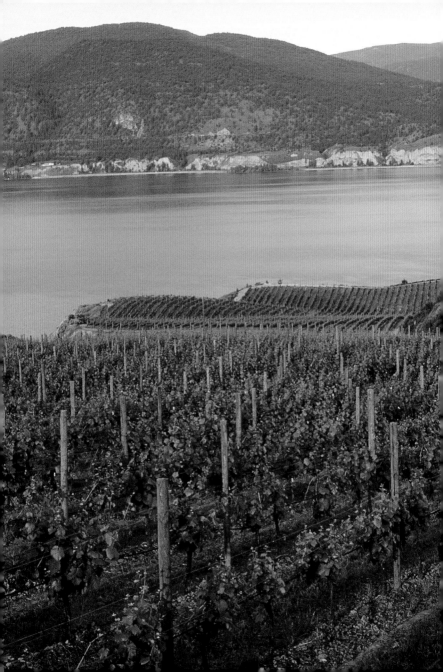

Vineyards | BRITISH COLUMBIA

The Okanagan Valley is one of the warmest regions in Canada, making it one of the country's premier wine-producing areas. Since the first commercial vineyard opened in the Okanagan in 1931, the *terroir* has proven popular with winemakers—today there are over 90 wineries in the area.

SIMON FRASER

Simon Fraser started working for the North West Company—a fur trading company that would eventually merge with the Hudson Bay Company—in 1792. He was made a partner in 1801 and was chosen to set up the company's first trading posts west of the Rocky Mountains. While Fraser was establishing the North West Company in Western Canada, he successfully led a group of men on a dangerous exploration of the Fraser River, which is named for him.

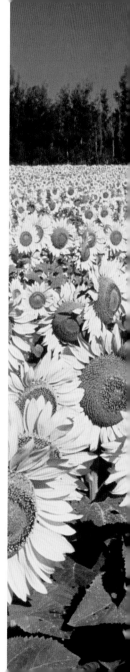

Sunflower Crops | MANITOBA

First Nations people have been cultivating sunflowers in North America for thousands of years—they ate the seeds, used the petals to make dyes, and extracted the oils. Today, many of the sunflowers grown in Manitoba are harvested for sunflower oil.

" *I think this is the greatest and best country in all the world, with its great sunlit spaces and its long, long roads, and best of all the roads that are not made yet, and the stories that no one has told because they are too busy living them.* "

—NELLIE McCLUNG, SUFFRAGIST

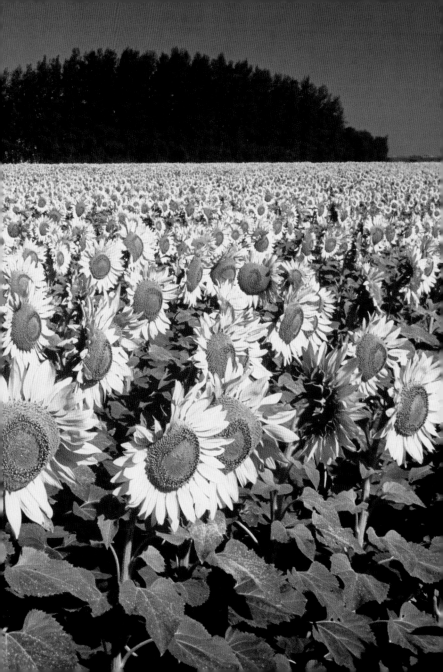

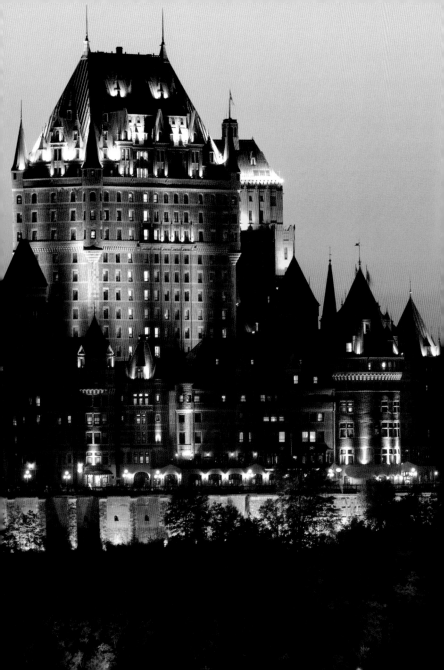

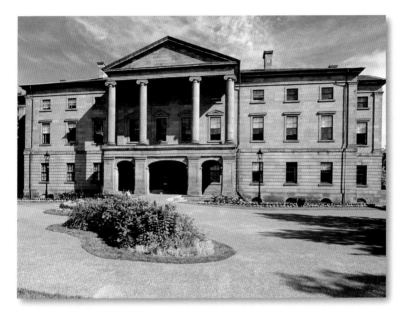

Province House | PRINCE EDWARD ISLAND

Canadian Confederation was born within the neoclassical walls of
Province House in Charlottetown. Delegates from British colonies in
North America—Prince Edward Island, New Brunswick, Nova Scotia,
and the Province of Canada—met here for the 1864 Charlottetown
Conference to discuss the possibility of union. Three years later,
Canada was born.

Fairmont Le Chateau Frontenac | QUEBEC

Featuring Middle Ages and Renaissance architectural styles, Fair-
mont Le Chateau Frontenac in Quebec City has hosted a long roster
of esteemed guests, from Queen Elizabeth and Princess Grace of
Monaco to Charles de Gaulle and Alfred Hitchcock.

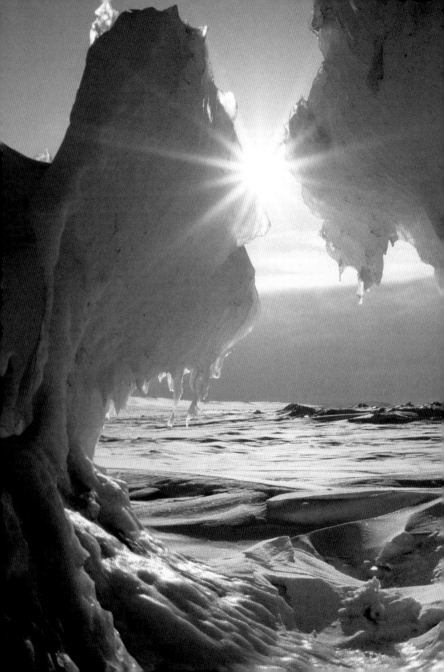

Beaufort Sea | YUKON

Climate change is having an effect on the frozen expanse of the Beaufort Sea. As the sea's ice pack warms up, fissures are appearing in the ice. This change in the ecosystem is having an adverse effect on polar bears, whose hunting habits depend on a thick layer of ice.

FRANCIS BEAUFORT

Sir Francis Beaufort standardized a system for measuring wind force, which is known as the Beaufort Scale. The scale, which was developed in the 1830s when Beaufort was in the Royal Navy, originally went from 0–12 (0 being no wind and calm waters and 12 being hurricane winds creating huge waves). The Beaufort Scale was extended to 17 in the mid-1940s to categorize cyclones and typhoons.

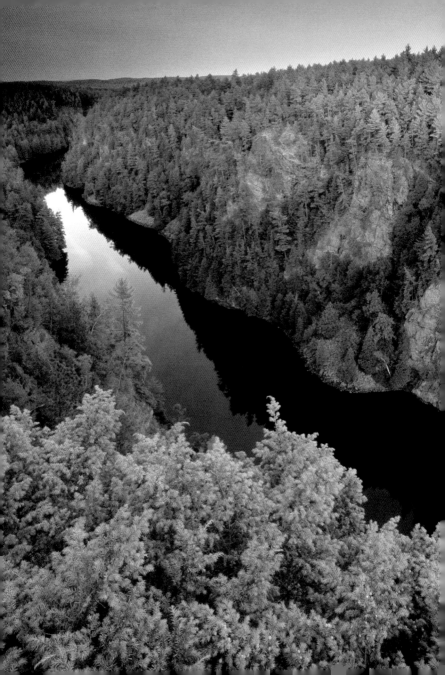

Algonquin Park | ONTARIO

Established in 1893, Algonquin is Canada's oldest provincial park. The Group of Seven, the country's most famous artist collective, used to come here on painting field trips. The park is home to megafauna such as deer, moose, and bears, as well as hundreds of different bird species.

GROUP OF SEVEN

Famous Canadian landscape painters A.Y. Jackson, Lawren Harris, Franklin Carmichael, Frank Johnston, Arthur Lismer, J.E.H. MacDonald, and Frederick Varley formed the Group of Seven in 1920. Tom Thomson often painted and travelled with the group and is sometimes cited as an honourary member, but he died in a boating accident here in Algonquin Park in 1917—three years before the group was officially formed.

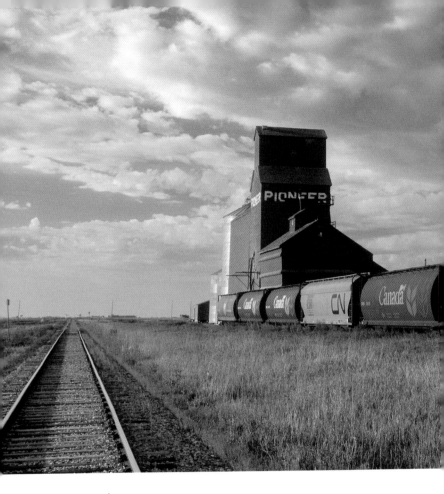

Railway | SASKATCHEWAN

When the Canadian Pacific Railway ventured into Saskatchewan in the late 19th century, settlements started booming. Ten years after a railway was built in Saskatoon, the community was incorporated as a village. Two years later it grew into a town, and three years after that, in 1906, it officially became a city.

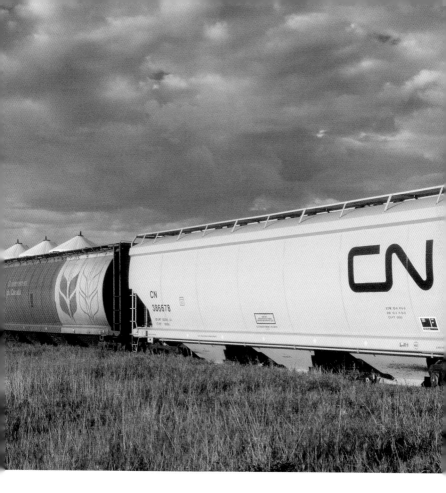

" *Man can now fly in the air like a bird, swim under the ocean like a fish, he can burrow into the ground like a mole. Now if only he could walk the earth like a man, this would be paradise.* "

—TOMMY DOUGLAS, FORMER SASKATCHEWAN PREMIER

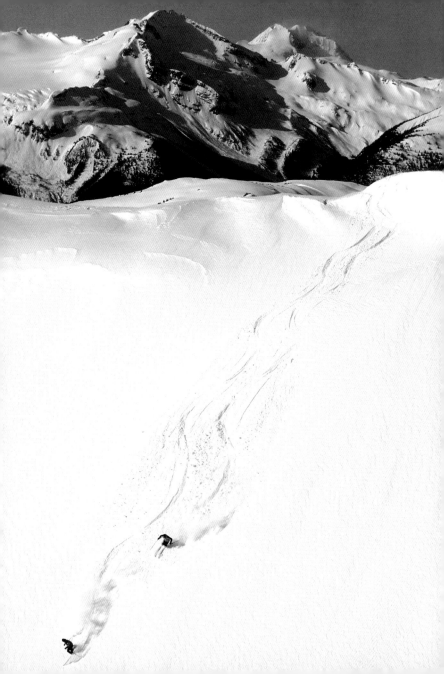

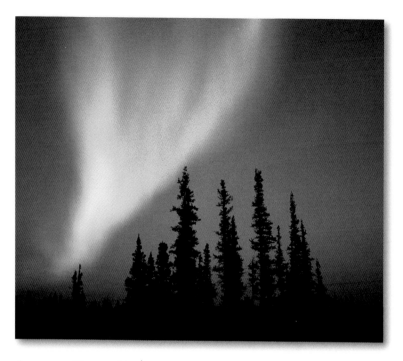

Aurora Borealis | NORTHWEST TERRITORIES

Aurora borealis—the Northern Lights—sweep across the Arctic sky.
This phenomenon is named for *Aurora*, the Greek goddess of the
dawn, and *Boreas*, the Greek god of the north wind.

Whistler Mountain | BRITISH COLUMBIA

Once inhabited primarily by Coast Salish First Nations people,
Whistler, British Columbia, is now home to one of the continent's
largest ski resorts. The skiing and sliding competitions in the 2010
Olympic and Paralympic Games will take place here on Whistler
and Blackcomb Mountains.

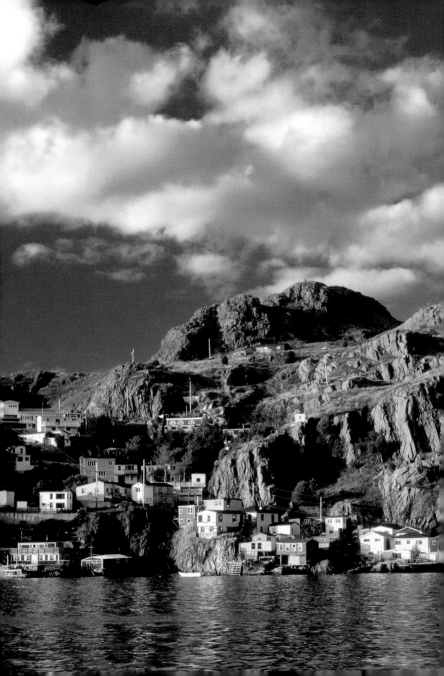

St. John's | 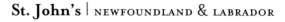 NEWFOUNDLAND & LABRADOR

Newfoundland & Labrador, which is the easternmost settlement in North America, is a land of extremes—Newfoundland even operates in its own time zone. The province's capital city of St. John's is considered the oldest English-founded settlement in the continent.

GIOVANNI CABOT

Giovanni Cabot, known as John Cabot, is thought to be the second European explorer to visit Atlantic Canada after Norse explorer Leif Eriksson. Cabot moved to England from Venice in the 15th century and undertook his voyages under the English flag. He landed here in the maritimes while he was looking for a passage to the Orient.

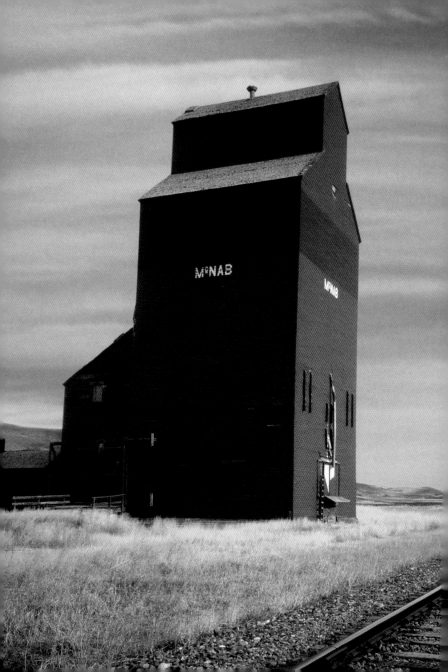

Grain Elevator | ALBERTA

Alberta is one of Canada's major producers of grain. The province once hosted over 1,700 grain elevators. There are now less than 300, as these classic buildings are being bulldozed to make way for more modern structures.

" *The grain elevator is the only architecture that's of any importance at all on the prairies. Like France's cathedrals, the prairies have their grain elevators. White and silver and red—I think they're lovely things. I'd like to spend two or three months just kicking around Alberta towns and painting them.* "

—A.Y. JACKSON, PAINTER, GROUP OF SEVEN

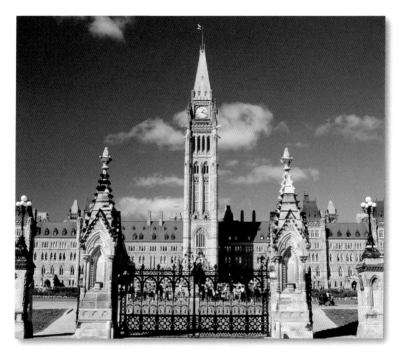

Parliament Buildings | OTTAWA

Queen Victoria chose Ottawa as the permanent capital of her colony the Province of Canada in 1857 because of its proximity to the border between Upper and Lower Canada (now Quebec and Ontario), and its distance from the American border.

Signal Hill | NEWFOUNDLAND & LABRADOR

The British defeated the French here at Signal Hill in 1762 during the last battle of the Seven Years' War in North America. Almost 150 years later in 1901 the world's first transatlantic radio signal was received here in Morse code from Cornwall, England.

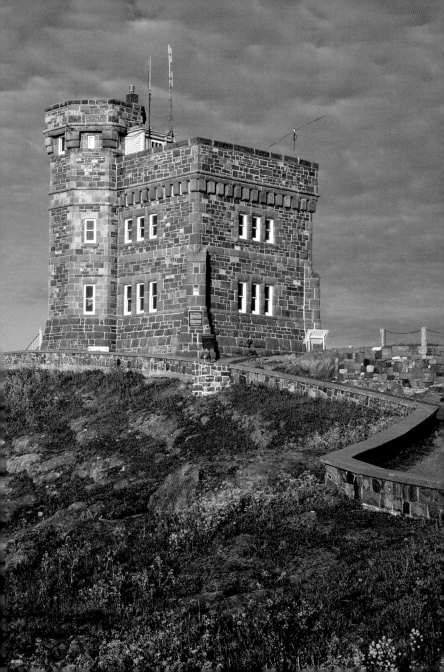

Harbour Quay | NOVA SCOTIA

A replica of the *Hector* sits in Pictou's Harbour Quay, where the original ship arrived with the first group of Scottish immigrants in the New World. The *Hector*'s 1773 journey took 11 weeks, and the people on board suffered through outbreaks of smallpox and dysentery. Still, many voyages followed and this port became known as the birthplace of "New Scotland."

" *Leave the beaten track behind occasionally and dive into the woods. Every time you do you will be certain to find something you've never seen before.* "

—ALEXANDER GRAHAM BELL, INVENTOR & SCIENTIST

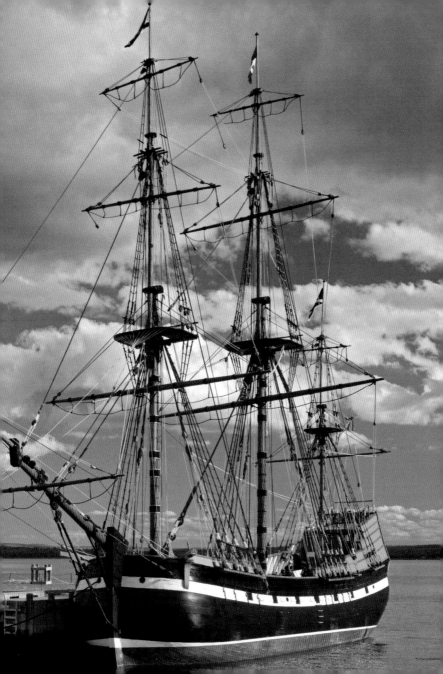

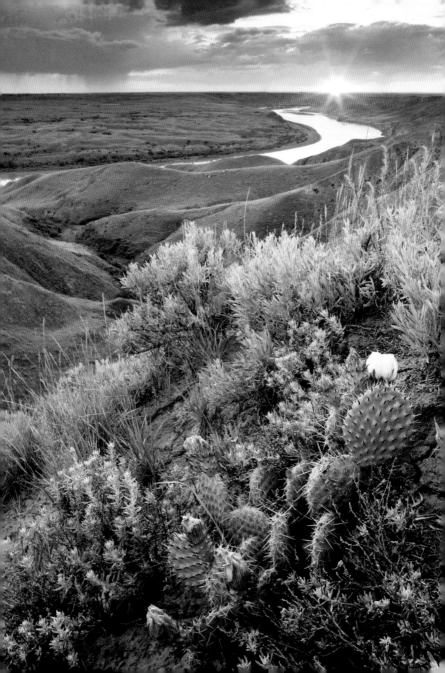

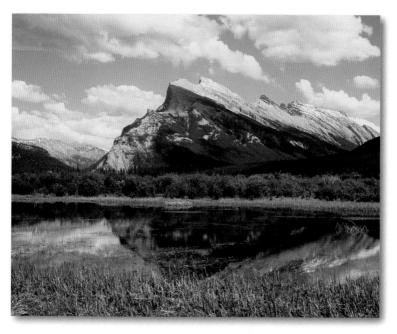

Mount Rundle | ALBERTA

Mount Rundle in Banff National Park stretches up to almost 3,000 metres (9,800 feet). The peak is named for Reverend Robert Rundle, a British Methodist missionary who travelled through Western Canada in the 1840s.

South Saskatchewan River | SASKATCHEWAN

The South Saskatchewan River flows through both Alberta and Saskatchewan and eventually empties into the Hudson Bay. Saskatchewan—which derives its name from the Plains Indian word *kisiskatchewan*, meaning "river that flows swiftly"—hosts some one hundred thousand bodies of water.

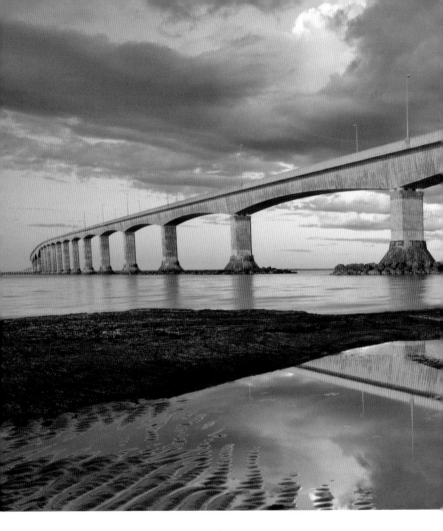

Confederation Bridge | P.E.I. TO NEW BRUNSWICK

Spanning the Abegweit Passage of the Northumberland Strait, Confederation Bridge connects the provinces of New Brunswick and Prince Edward Island. The world's longest bridge over ice-covered

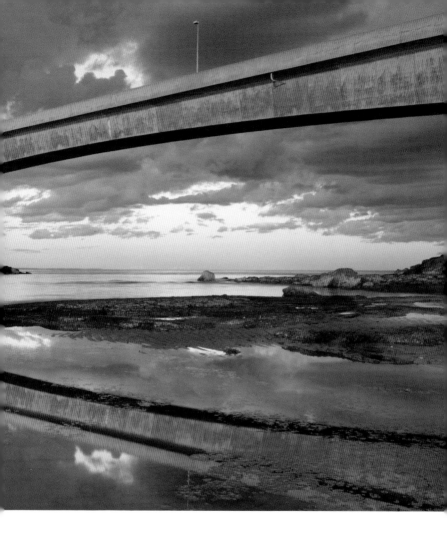

waters, Confederation Bridge took over four years to build and
was finally completed in 1997 at a cost of over one billion dollars.
Crossing the 12.9 kilometre (8 mile) bridge takes about ten minutes.

Forillon Park | QUEBEC

This cluster of houses at Grand Grave National Heritage Site in Forillon National Park harkens back to the area's heyday as a busy fishing village in the late 19th and early 20th century.

JACQUES CARTIER

French explorer and navigator Jacques Cartier made three voyages to North America in the 16th century. During his first voyage, he sailed the Strait of Belle Isle between Newfoundland and Labrador, found the St. Lawrence River, and saw both the Magdalen Islands and Prince Edward Island. On his second voyage, Cartier further explored the St. Lawrence River. On Cartier's third journey to Canada, he sailed up the St. Lawrence River again and this time established a colony. The colony was abandoned after only two years.

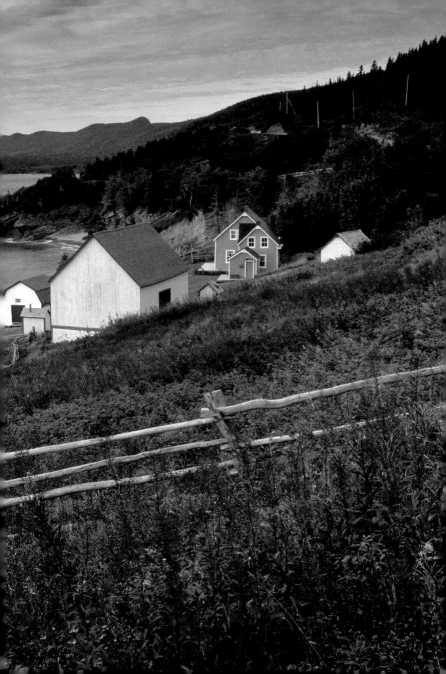

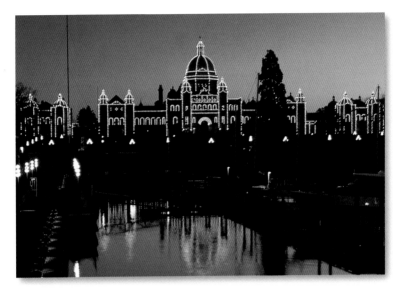

Parliament Buildings | BRITISH COLUMBIA

Thousands of little lights illuminate the Parliament Buildings in Victoria, British Columbia's capital city. The elegant neo-baroque building opened to the public in 1898. It was completed at a cost of nearly one million dollars—almost double the original budget.

Rideau Canal | ONTARIO

The Rideau Canal is a string of interconnected lakes, rivers, and canals connecting Kingston and Ottawa. Over 200 kilometres (125 miles) long, the canal is almost entirely natural—only ten percent is constructed. The canal was initially built for military reasons: the British wanted to protect their Canadian colony from American invasion and it provided a safe route for transporting supplies to their naval base in Kingston.

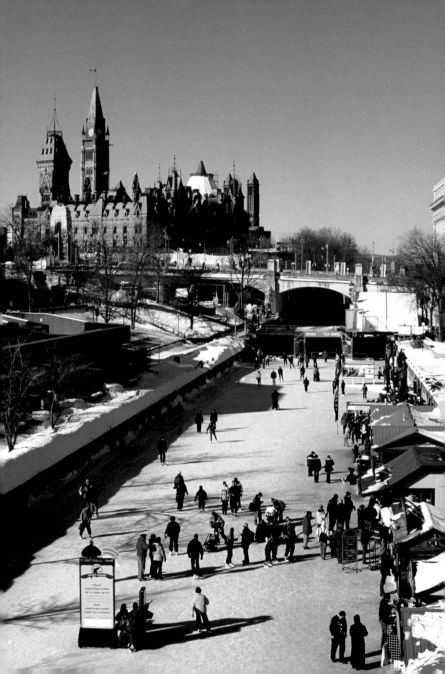

Lake Manitoba | MANITOBA

Derived from the Cree word *manitowapow* and the Ojibway words *Manitou Bou*, Manitoba means "the narrows of the Great Spirit." The province is also known as the Land of 100,000 Lakes.

> *We must cherish our inheritance. We must preserve our nationality for the youth of our future. The story should be written down to pass on.*

—LOUIS RIEL, MÉTIS LEADER

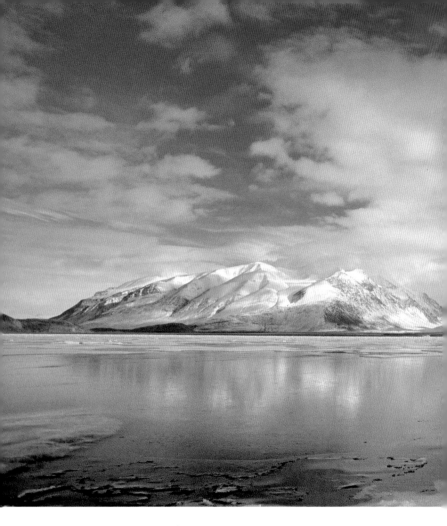

Ellesmere Island | NUNAVUT

Nunavut's Ellesmere Island is Canada's third-largest island and the world's tenth. It hosts the world's two northernmost human settlements; both are weather observatories and military stations.

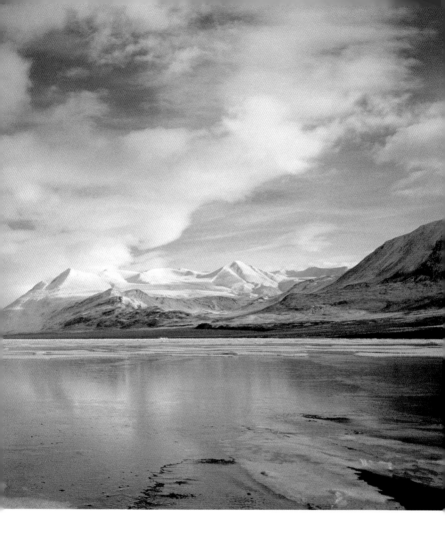

" *Only the spirits of the air know what awaits me behind the mountains, but still I travel onwards.* "
—INUIT PROVERB

Balancing Rock | NOVA SCOTIA

Thousands of years ago this rock column was simply part of the rugged coastline in Tiverton, Nova Scotia. Years of wind and water erosion have carved the precarious-looking tower of Balancing Rock from the basalt that comprises the shoreline's rocky cliffs.

" *We must not forget that days may come when our patience, our endurance and our fortitude will be tried to the utmost. In those days, let us see to it that no heart grows faint and that no courage be found wanting...* "

—SIR ROBERT BORDEN, FORMER PRIME MINISTER OF CANADA

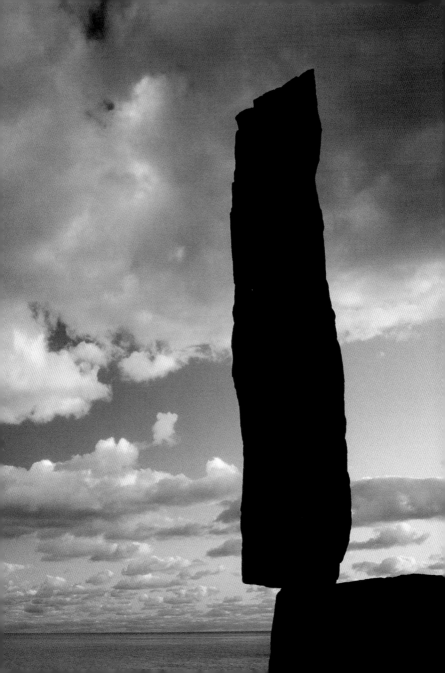

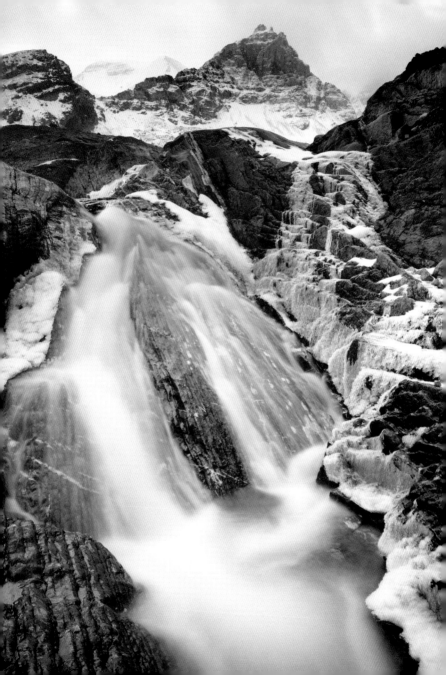

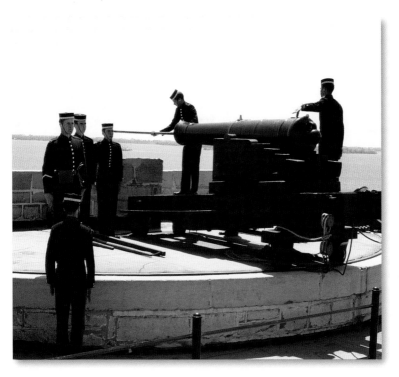

Fort Henry National Historic Site | ONTARIO

The British erected a structure here at Fort Henry during the War
of 1812 to protect their Canadian colony from the United States of
America. This second fort was built in 1837 to protect the nearby
dockyards and trade routes along the Rideau Canal, the St. Lawrence
River, and Lake Ontario.

Mount Andromeda | ALBERTA

Mount Andromeda rises dramatically out of the Columbia Icefield to
a height of 3,450 metres (11,320 feet).

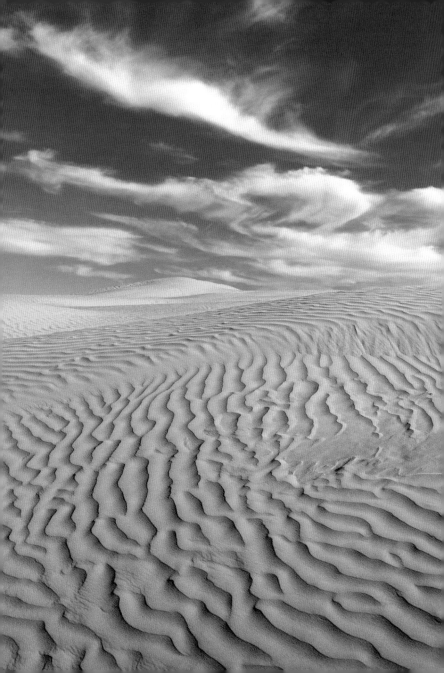

Great Sand Hills | SASKATCHEWAN

Some dunes in Saskatchewan's Great Sand Hills—which reach up to 15 metres (50 feet). These sand hills—which make up the largest connected dunes in the Prairies—cover almost 2,000 square kilometres (750 square miles).

> " *I am a Canadian, free to speak without fear, free to worship in my own way, free to stand for what I think is right, free to oppose what I believe is wrong, and free to choose those who shall govern my country. This heritage of freedom I pledge to uphold for myself and all mankind.* "
>
> —JOHN DIEFENBAKER, FORMER PRIME MINISTER OF CANADA

Totem Pole | BRITISH COLUMBIA

Totem poles, each one intricately and meticulously carved from a single tree, are an ancient aspect of Northwest Coast native culture. The poles often function as symbols of clan and family lineage, or recount legends or historical events.

" *You must be absolutely honest and true in the depicting of a totem for meaning is attached to every line. You must be most particular about detail and proportion.* **"**

—EMILY CARR, ARTIST & WRITER

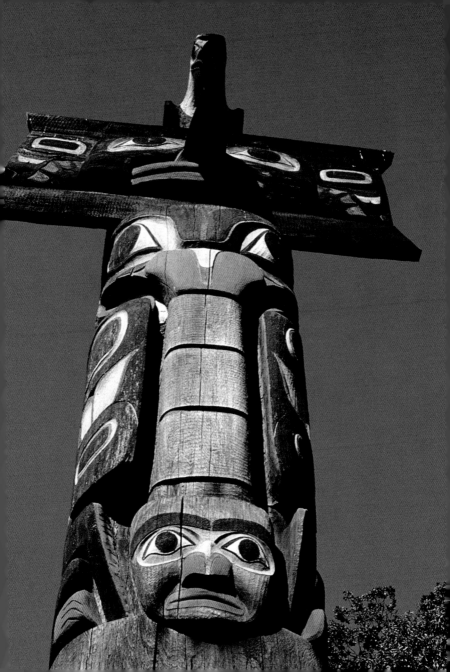

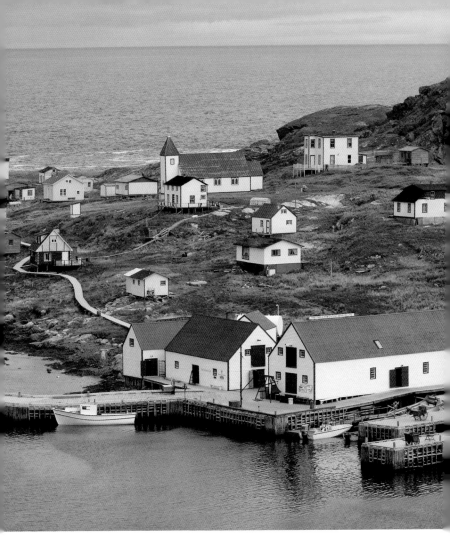

Labrador | NEWFOUNDLAND & LABRADOR

A constitutional amendment in 2001 added the name Labrador to what was then known as the province of Newfoundland. Although

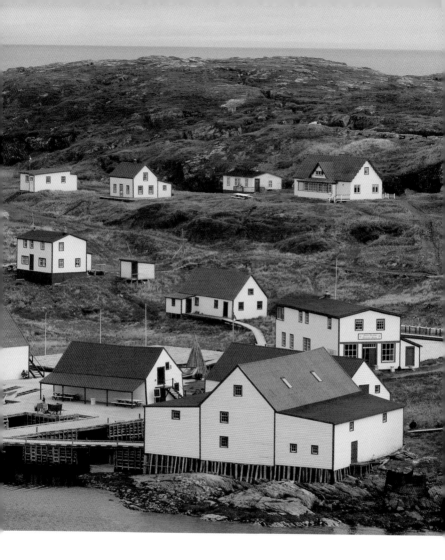

Labrador is almost 35 times larger in area than the island of New-foundland, its population is more than 16 times smaller.

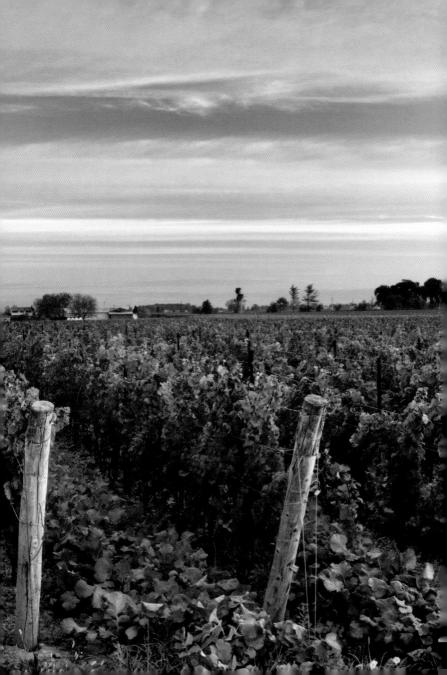

Vineyards | ONTARIO

Ontario's Niagara Peninsula is the largest wine-growing region in Canada, hosting over 125 wineries. The temperate climate in this region is comparable to some of the world's other premier wine-producing areas, even France's Burgundy region and the Loire Valley.

SIR JOHN A. MACDONALD

Sir John A. Macdonald is often referred to as the "founding father of Canada." A Scottish immigrant who came to Canada as a child, Macdonald began his career as a lawyer, was soon elected to the Legislative Assembly, and then became the Premier of Upper Canada. When the Dominion of Canada was formed in 1867 Macdonald served as its first Prime Minister; he served a second term from 1878–1891. He is remembered for uniting seemingly divisive French and English colonies and for supporting the construction of a national railway.

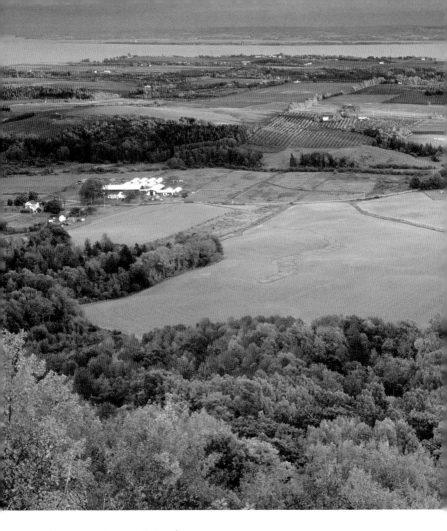

Annapolis Valley | NOVA SCOTIA

Nicknamed the "breadbasket of Nova Scotia," these fertile fields of the Annapolis Valley are the province's agricultural core. French farmers called Acadians settled in the area in the 17th century and

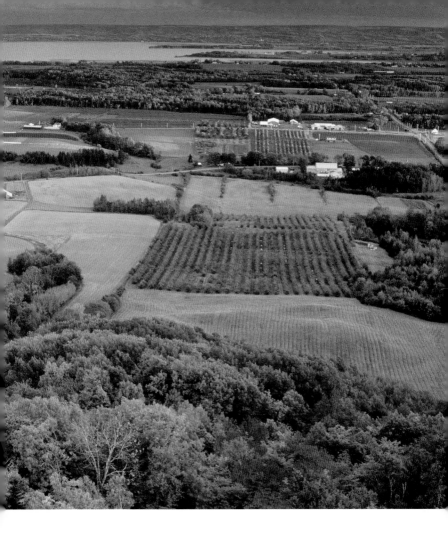

together with the area's Mi'kmaq inhabitants, they laid the foundations for the many vineyards, orchards, and farms that blanket the valley today.

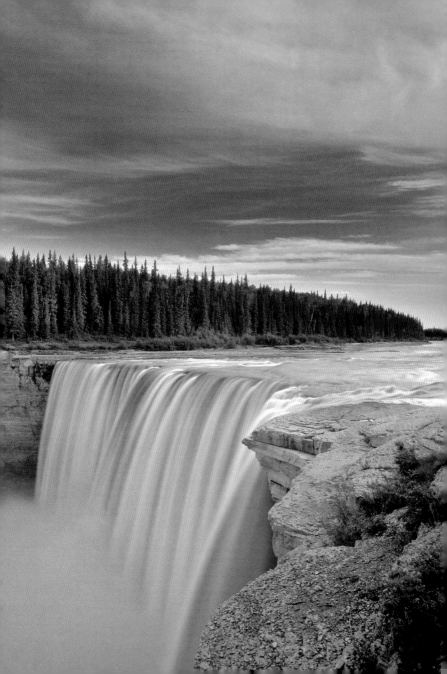

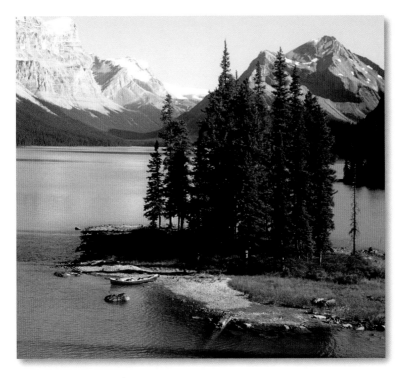

Maligne Lake | ALBERTA

Stretching for 22 kilometres (13 miles), Maligne Lake is the longest lake in the Canadian Rockies.

Alexandra Falls | NORTHWEST TERRITORIES

First Nations people, primarily the Dene and the Inuit, have been living in the Northwest Territories for thousands of years. The Slavey Dene people built a cluster of log cabins near Hay River in the late 19th century, which is thought to be the area's first permanent settlement.

Riding Mountain | MANITOBA

This land was once prime hunting and fishing area for First Nations people and home to the Ojibway. Riding Mountain National Park was formed in 1929, and three years later conservationist Archibald Belaney, better known as "Grey Owl," moved to a cabin on this land. He was hired to re-establish the park's diminishing beaver population.

" *Give me a good canoe, a pair of Jibway snowshoes, my beaver, my family, and ten thousand square miles of wilderness and I'm happy.* **"**

—ARCHIBALD BELANEY A.K.A. GREY OWL, CONSERVATIONIST

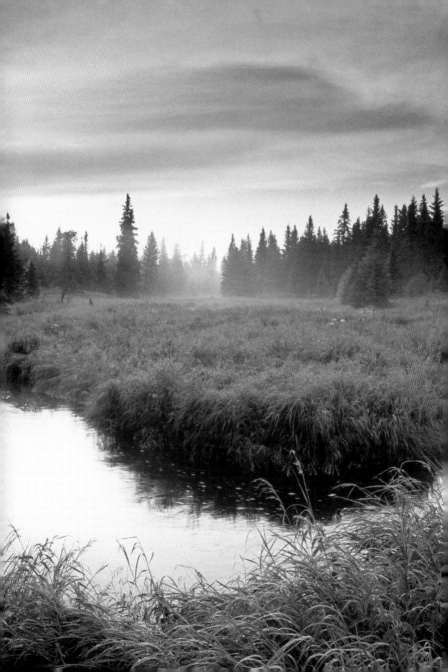

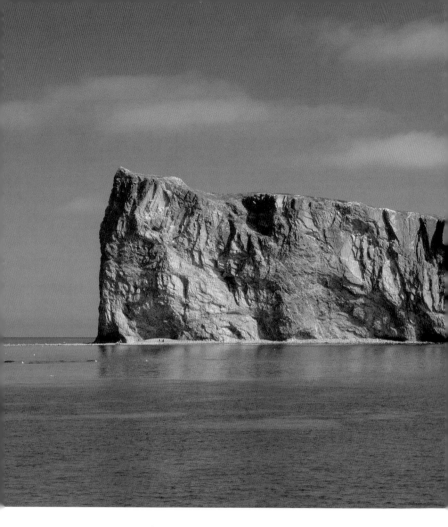

Rocher Percé | QUEBEC

The tallest point of this massive limestone butte is almost 90 metres (295 feet) high. Known as *Rocher Percé* ("pierced rock"), this natural monolith is one of Quebec's most famous landmarks.

78

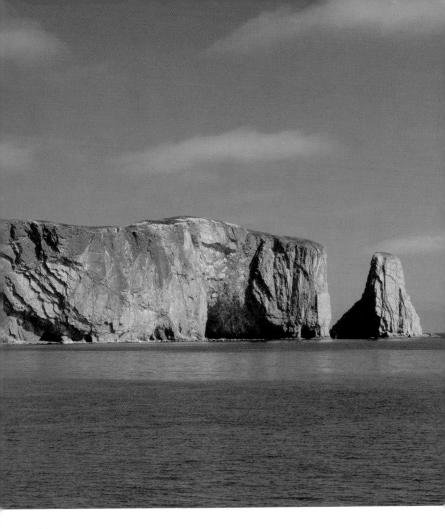

66 *Our hopes are high. Our faith in the people is great. Our courage is strong. And our dreams for this beautiful country will never die.* 99

—PIERRE ELLIOTT TRUDEAU, FORMER PRIME MINISTER OF CANADA

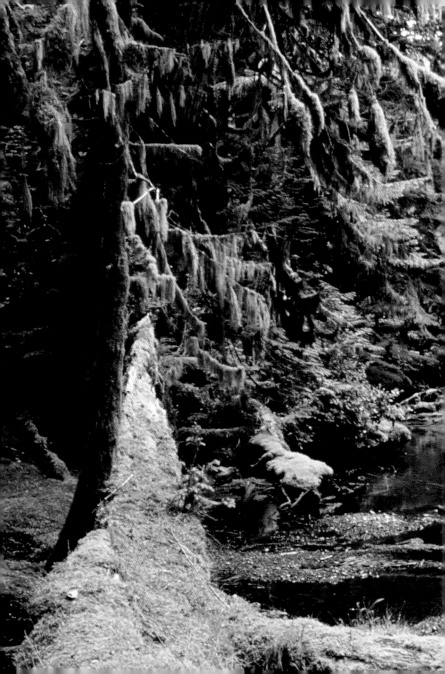

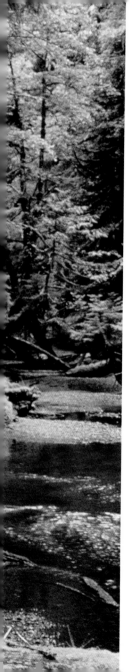

Cathedral Grove | BRITISH COLUMBIA

Some of these magnificent old-growth trees in Cathedral Grove on Vancouver Island are 800 years old. One of the area's tallest trees is a Douglas fir, which reaches up to almost 23 metres (75 feet).

CAPTAIN GEORGE VANCOUVER

Explorer George Vancouver, for whom the city of Vancouver and Vancouver Island are named, started his career in the service of Captain James Cook. Vancouver started leading his own voyages as the commander of the *Discovery* in 1790. After exploring Australia, New Zealand, and the Hawaiian Islands, Vancouver came to North America and charted and mapped the Pacific Coast of British Columbia.

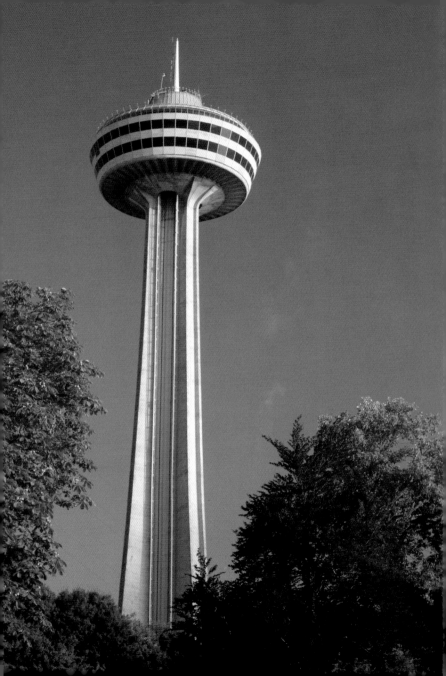

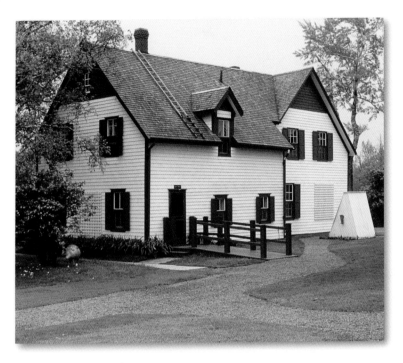

Green Gables | PRINCE EDWARD ISLAND

This 19th century farmhouse inspired the setting for Lucy Maud Montgomery's iconic novel *Anne of Green Gables*. Montgomery visited her relatives here when she was a child and later imagined it as the home of beloved red-headed orphan Anne Shirley.

Canadian National Tower | ONTARIO

The tallest free-standing structure in the world until 2007, Toronto's CN Tower still holds the title in North America at a height of 553 metres (1,815 feet). It was completed in 1976, and is a telecommunications tower and tourist mecca.

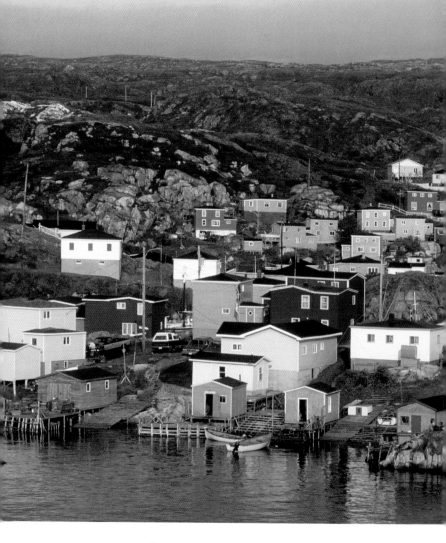

Rose Blanche | NEWFOUNDLAND & LABRADOR

White quartz outcroppings surrounding Rose Blanche in Newfoundland and Labrador give the town its name. Over the years, *roche*

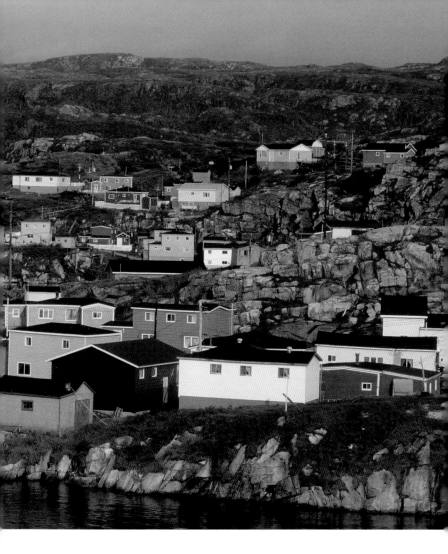

blanche (literally, "white rock") morphed into the coastal town's present name.

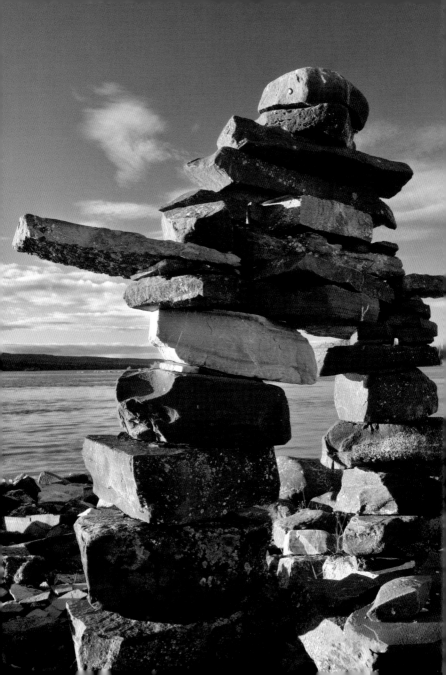

Inuksuk | NORTHWEST TERRITORIES

Inuksuks—rock cairns assembled in the shape of a human figure—appear throughout the Arctic. They were built by hunters who needed navigational landmarks in the stark tundra.

> **"** *Those who know how to play can easily leap over the adversities of life. And one who knows how to sing and laugh never brews mischief.* **"**
> —INUIT PROVERB

Wheat Field | SASKATCHEWAN

Although wheat is not indigenous to North America—European settlers introduced it—the grain thrives in the Prairies. Saskatchewan, which is dubbed the "breadbasket of Canada," produces almost two-thirds of the country's wheat.

> *The first time I ever felt the necessity or inevitableness of verse, was in the desire to reproduce the peculiar quality of feeling which is induced by the flat spaces and wide horizons of the virgin prairie of western Canada.*
> —T.E. HULME, POET & WRITER

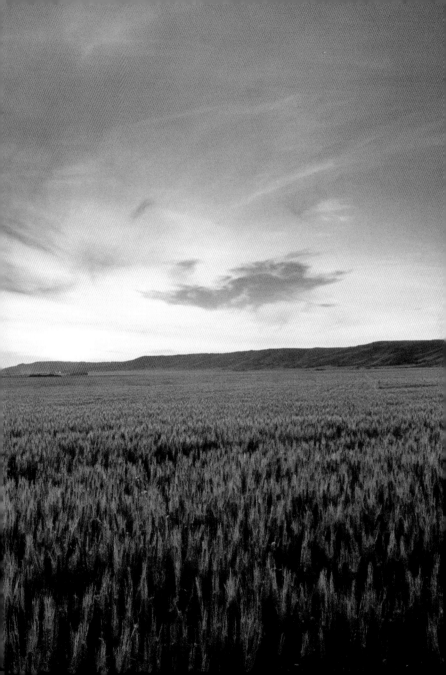

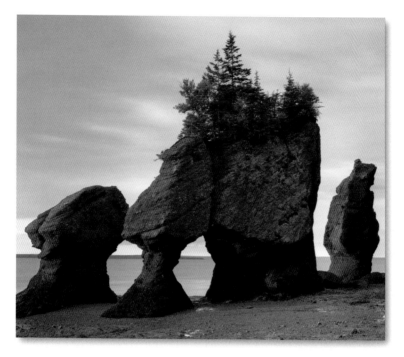

Bay of Fundy | NEW BRUNSWICK

Thousands of years of water erosion by the tides of the Bay of Fundy have whittled away the bottoms of the Hopewell Rocks causing these unique formations.

Canola Field | MANITOBA

Developed by a plant breeder at the University of Manitoba in 1974, canola is now one of the province's most valuable crops. A derivative of rapeseed, canola is used in myriad products, from oil and ink to fertilizer and cosmetics. The name canola is a combination of the words *Canada* and *oil*.

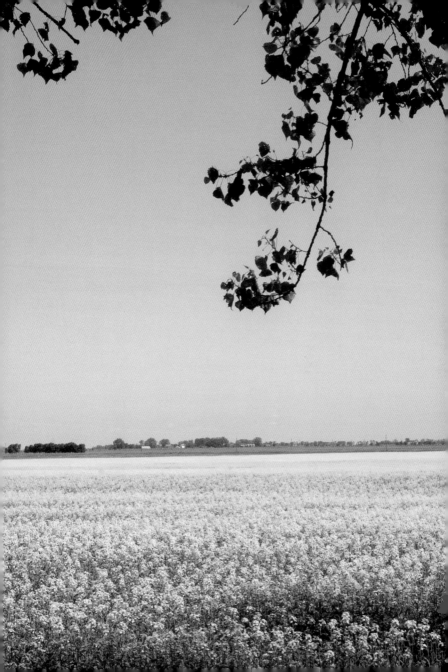

Orchard | BRITISH COLUMBIA

The fertile fields of British Columbia's Okanagan Valley make up Canada's pre-eminent fruit-producing region. Dubbed the "fruit capital of Canada," the Okanagan is home to over a thousand fruit growers whose farms yield more than $150 million worth of fresh fruit every year.

" *We are a young country; we must build on the solid rock of sound economic policies and balanced budgets. But, we must be prepared, as a nation, to step from the solid rock onto new ground. The path of ease, the path of tradition alone, is not the path of a greater Canada.* "

—W.A.C. BENNETT, FORMER BRITISH COLUMBIA PREMIER

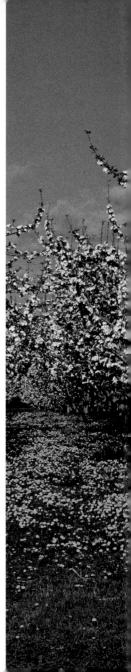

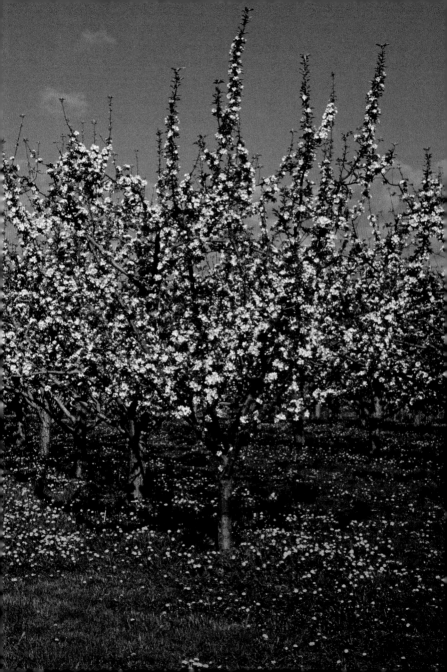

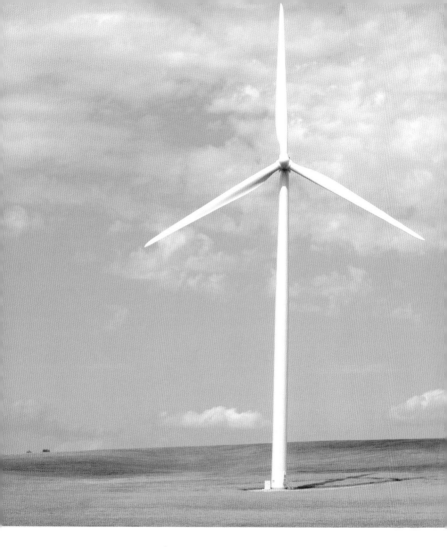

Wind Turbines | MANITOBA

Harnessing the power of the wind is becoming a popular way to produce energy. Manitoba Hydro now has multiple wind-monitoring

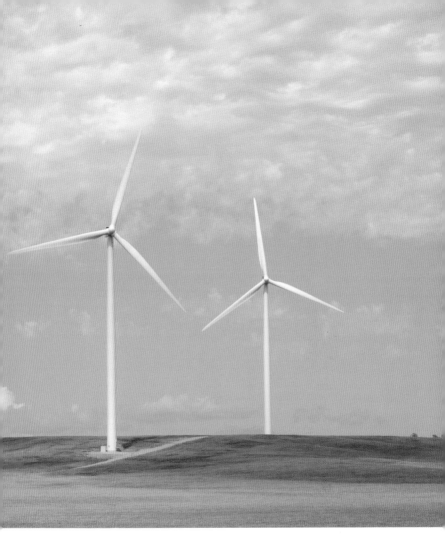

facilities throughout the province to determine the most effective
places to build new turbines.

Photo Credits

Bob Herger 6–7, 25, 54, 67, 80

Wayne Lynch / copyright Wayne Lynch 8, 18–19, 24, 32–33, 39, 58–59

Darwin Wiggett / www.darwinwiggett.com 1, 3, 9, 10–11, 12–13, 14–15, 16, 17, 20–21, 22–23, 34–35, 36–37, 40, 42, 46–47, 48, 50–51, 52–53, 56, 60–61, 62, 64–65, 70–71, 72–73, 74, 77, 78–79, 82, 84–85, 86–87, 88–89, 90

Michael E. Burch 26–27, 49, 63, 75, 91, 93, 94–95

Dave Reede / All Canada Photos 28–29

Chris Cheadle / All Canada Photos 30

Barrett&MacKay / All Canada Photos 31, 55

Randy Lincks / All Canada Photos 38

Miles Ertman / All Canada Photos 44

Dale Wilson / All Canada Photos 45

John Sylvester / All Canada Photos 68–69

J.A. Kraulis / All Canada Photos 83